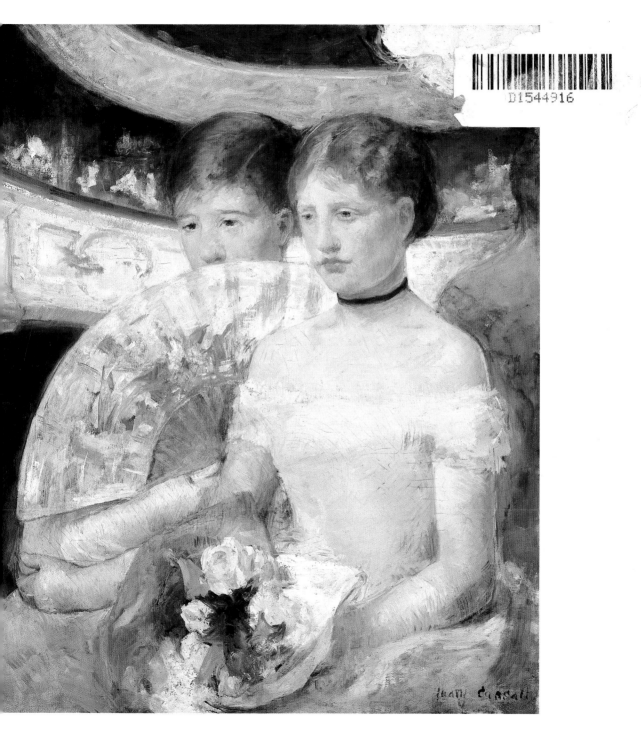

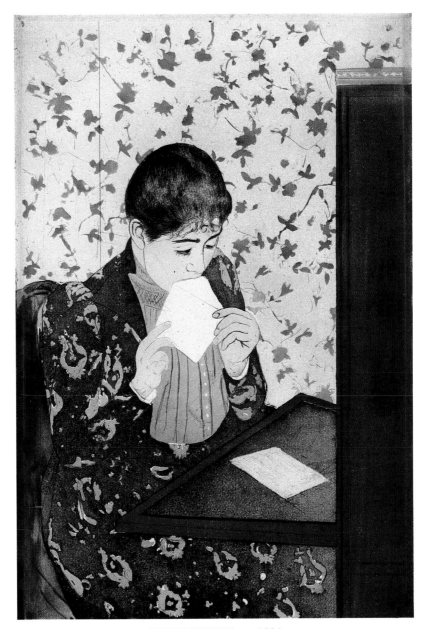

THE LETTER, c. 1891
Soft-ground etching, drypoint and aquatint in color, 34.4 × 22.6 cm (13⅝ × 8¹⁵⁄₁₆ in.).
National Gallery of Art, Washington, D.C., Chester Dale Collection, 1963.10.251.

THE

mary cassatt

DATEBOOK

Featuring Works by Mary Cassatt
from the National Gallery of Art,
Washington, D.C.

HUDSON HILLS PRESS, NEW YORK

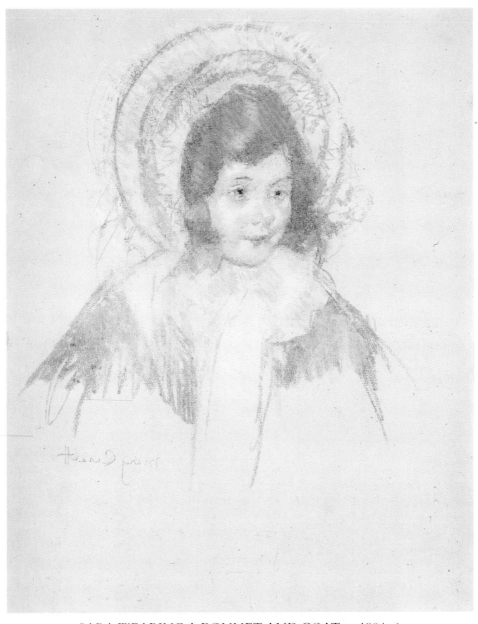

SARA WEARING A BONNET AND COAT, c. 1904–6
Counterproof of a pastel, chine collé and reworked, 72.9 × 58.1 cm (28¾ × 22⅞ in.).
National Gallery of Art, Washington, D.C., Rosenwald Collection, 1980.45.9.

january

1 _____
2 _____
3 _____
4 _____
5 _____
6 _____
7 _____
8 _____
9 _____
10 _____
11 _____
12 _____
13 _____
14 _____
15 _____

16 _____
17 _____
18 _____
19 _____
20 _____
21 _____
22 _____
23 _____
24 _____
25 _____
26 _____
27 _____
28 _____
29 _____
30 _____

31 _____

february

1	15
2	16
3	17
4	18
5	19
6	20
7	21
8	22
9	23
10	24
11	25
12	26
13	27
14	28

29

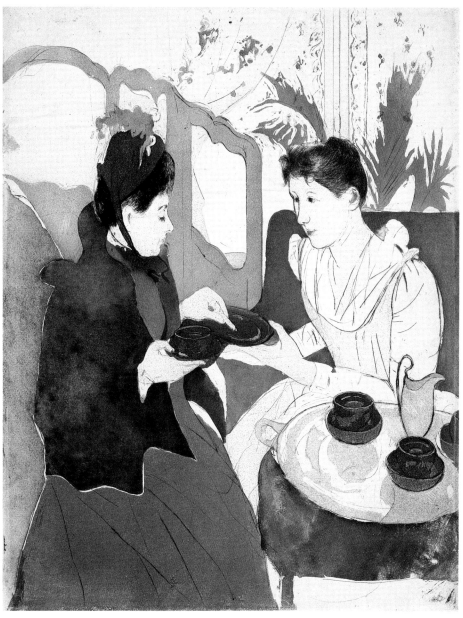

AFTERNOON TEA PARTY, 1891
Etching, drypoint and aquatint in color, 34.2 × 26.3 cm (13½ × 10⅜ in.).
National Gallery of Art, Washington, D.C., Rosenwald Collection, 1943.3.2743.

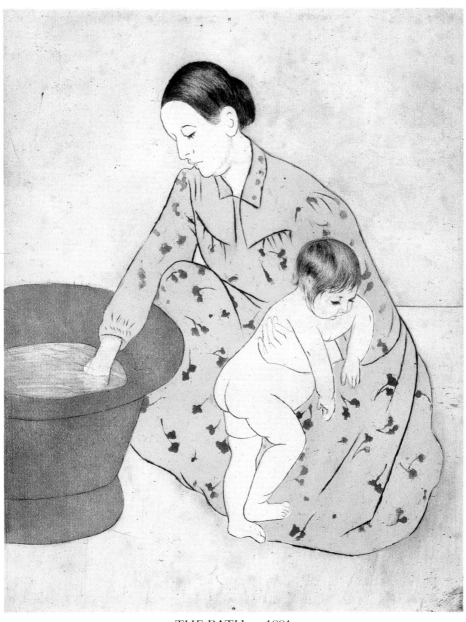

THE BATH, c. 1891
Drypoint and soft-ground etching in color, 31.2 × 25.0 cm (12⁵/₁₆ × 9¹³/₁₆ in.).
National Gallery of Art, Washington, D.C., Chester Dale Collection, 1963.10.248.

march

1 _____
2 _____
3 _____
4 _____
5 _____
6 _____
7 _____
8 _____
9 _____
10 _____
11 _____
12 _____
13 _____
14 _____
15 _____

16 _____
17 _____
18 _____
19 _____
20 _____
21 _____
22 _____
23 _____
24 _____
25 _____
26 _____
27 _____
28 _____
29 _____
30 _____

31 _____

april

1 _____	16 _____
2 _____	17 _____
3 _____	18 _____
4 _____	19 _____
5 _____	20 _____
6 _____	21 _____
7 _____	22 _____
8 _____	23 _____
9 _____	24 _____
10 _____	25 _____
11 _____	26 _____
12 _____	27 _____
13 _____	28 _____
14 _____	29 _____
15 _____	30 _____

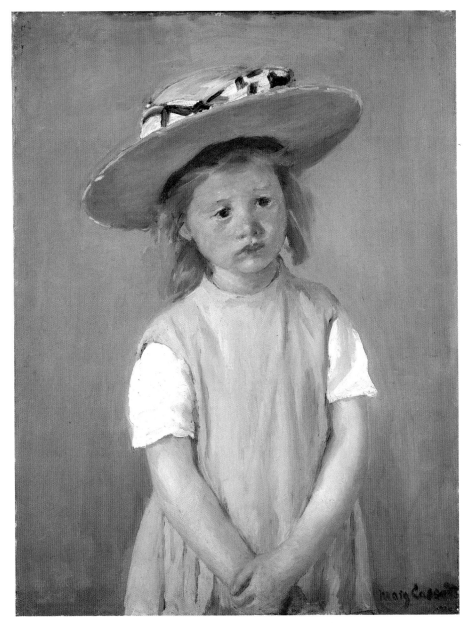

CHILD IN A STRAW HAT, c. 1886
Oil on canvas, 65.3 × 49.5 cm (25¾ × 19½ in.).
National Gallery of Art, Washington, D.C., Collection of Mr. and Mrs. Paul Mellon, 1983.1.17.

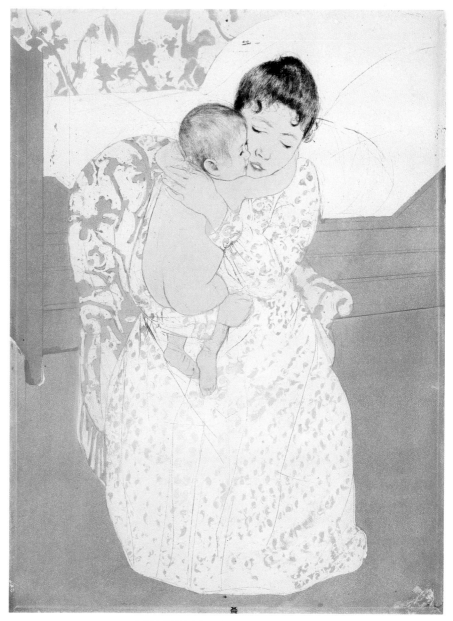

MATERNAL CARESS, c. 1891
Drypoint, soft-ground etching and aquatint in color, 36.7 × 26.8 cm (14½ × 10⁹⁄₁₆ in.).
National Gallery of Art, Washington, D.C., Chester Dale Collection, 1963.10.255.

may

1 _____

2 _____

3 _____

4 _____

5 _____

6 _____

7 _____

8 _____

9 _____

10 _____

11 _____

12 _____

13 _____

14 _____

15 _____

16 _____

17 _____

18 _____

19 _____

20 _____

21 _____

22 _____

23 _____

24 _____

25 _____

26 _____

27 _____

28 _____

29 _____

30 _____

31 _____

june

1 _____

2 _____

3 _____

4 _____

5 _____

6 _____

7 _____

8 _____

9 _____

10 _____

11 _____

12 _____

13 _____

14 _____

15 _____

16 _____

17 _____

18 _____

19 _____

20 _____

21 _____

22 _____

23 _____

24 _____

25 _____

26 _____

27 _____

28 _____

29 _____

30 _____

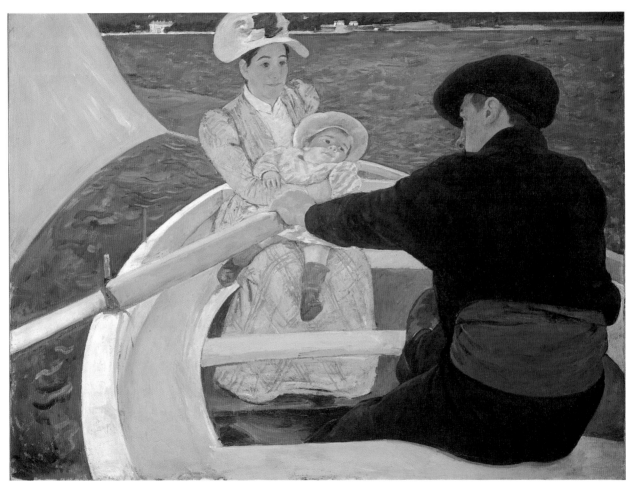

THE BOATING PARTY, 1893/94
Oil on canvas, 90.2 × 117.1 cm (35½ × 46⅛ in.).
National Gallery of Art, Washington, D.C., Chester Dale Collection, 1963.10.94.

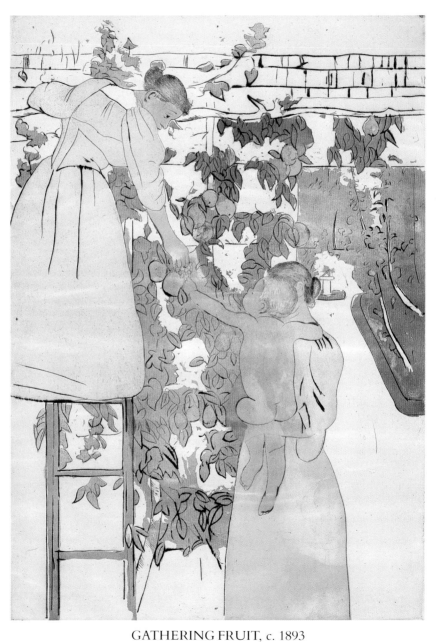

GATHERING FRUIT, c. 1893
Etching, drypoint and aquatint in color, 42.5 × 29.8 cm (16¾ × 11¾ in.).
National Gallery of Art, Washington, D.C., Rosenwald Collection, 1943.3.2756.

july

1		16	
2		17	
3		18	
4		19	
5		20	
6		21	
7		22	
8		23	
9		24	
10		25	
11		26	
12		27	
13		28	
14		29	
15		30	

31 _____

august

1 _____

2 _____

3 _____

4 _____

5 _____

6 _____

7 _____

8 _____

9 _____

10 _____

11 _____

12 _____

13 _____

14 _____

15 _____

16 _____

17 _____

18 _____

19 _____

20 _____

21 _____

22 _____

23 _____

24 _____

25 _____

26 _____

27 _____

28 _____

29 _____

30 _____

31 _____

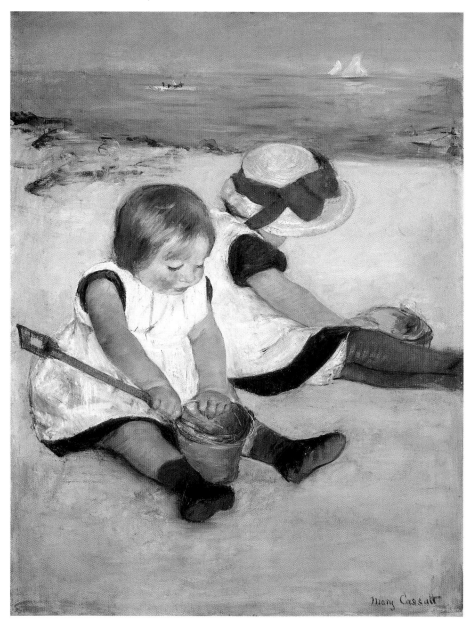

CHILDREN PLAYING ON THE BEACH, 1884
Oil on canvas, 97.4 × 74.2 cm (38⅜ × 29¼ in.).
National Gallery of Art, Washington, D.C., Ailsa Mellon Bruce Collection, 1970.17.19.

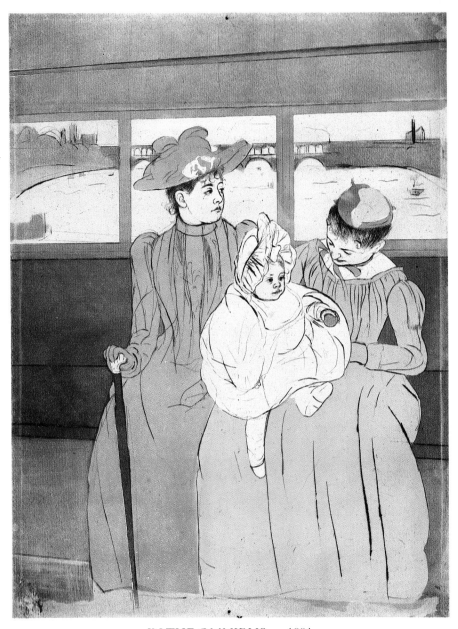

IN THE OMNIBUS, c. 1891
Soft-ground etching, drypoint and aquatint in color, 36.6 × 26.7 cm (14⁵/₁₆ × 10½ in.).
National Gallery of Art, Washington, D.C., Chester Dale Collection, 1963.10.250.

september

1
2
3
4
5
6
7
8
9
10
11
12
13
14
15

16
17
18
19
20
21
22
23
24
25
26
27
28
29
30

october

1 _____
2 _____
3 _____
4 _____
5 _____
6 _____
7 _____
8 _____
9 _____
10 _____
11 _____
12 _____
13 _____
14 _____
15 _____

16 _____
17 _____
18 _____
19 _____
20 _____
21 _____
22 _____
23 _____
24 _____
25 _____
26 _____
27 _____
28 _____
29 _____
30 _____

31 _____

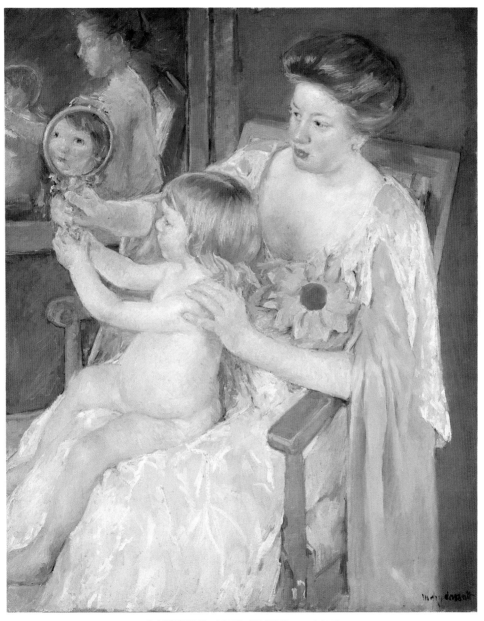

MOTHER AND CHILD, c. 1905
Oil on canvas, 92.1 × 73.7 cm (36¼ × 29 in.).
National Gallery of Art, Washington, D.C., Chester Dale Collection, 1963.10.98.

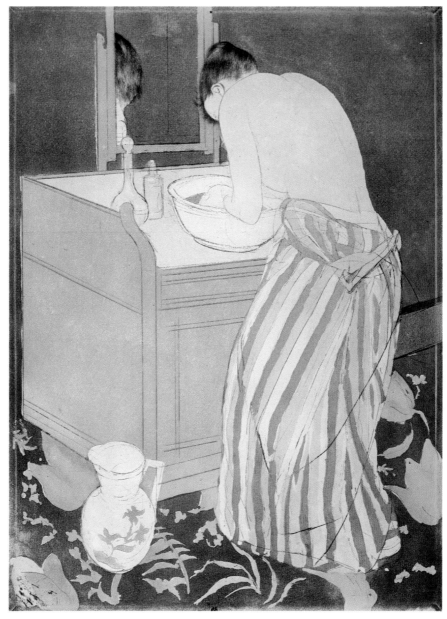

WOMAN BATHING, c. 1891
Drypoint and soft-ground etching in color, 36.6 × 26.8 cm (14⁵⁄₁₆ × 10⁹⁄₁₆ in.).
National Gallery of Art, Washington, D.C., Rosenwald Collection, 1946.21.92.

november

1	16
2	17
3	18
4	19
5	20
6	21
7	22
8	23
9	24
10	25
11	26
12	27
13	28
14	29
15	30

december

1 _____

2 _____

3 _____

4 _____

5 _____

6 _____

7 _____

8 _____

9 _____

10 _____

11 _____

12 _____

13 _____

14 _____

15 _____

16 _____

17 _____

18 _____

19 _____

20 _____

21 _____

22 _____

23 _____

24 _____

25 _____

26 _____

27 _____

28 _____

29 _____

30 _____

31 _____

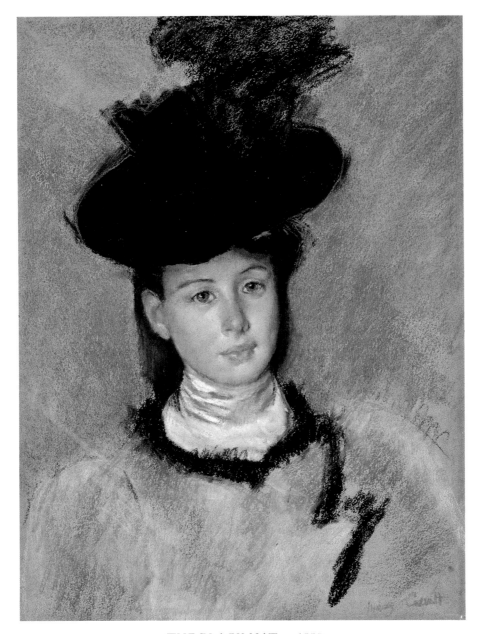

THE BLACK HAT, c. 1890
Pastel, 61.0 × 45.5 cm (24 × 18 in.).
National Gallery of Art, Washington, D.C., Collection of Mr. and Mrs. Paul Mellon, 1985.64.81.

Distributed in the United States, its territories and possessions, and Canada by National Book Network.
Distributed in the United Kingdom, Eire, and Europe by Art Books International Ltd.

EDITOR AND PUBLISHER: Paul Anbinder
DESIGNER: Nai Y. Chang
COMPOSITION: U.S. Lithograph, typographers
MANUFACTURED IN JAPAN BY Toppan Printing Company

ISBN 0-55595-006-X

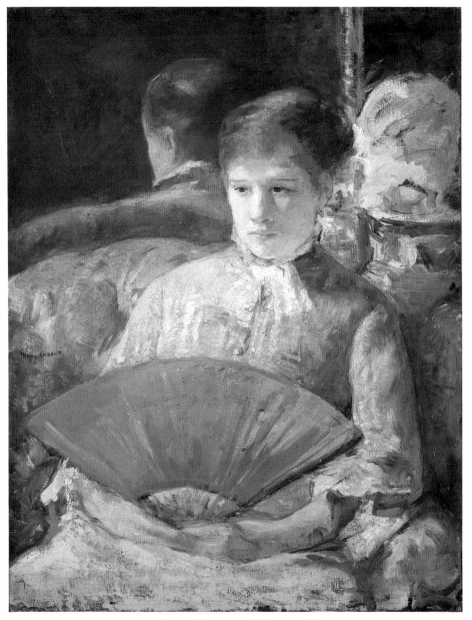

MISS MARY ELLISON, c. 1880
Oil on canvas, 85.0 × 65.3 cm (33½ × 25¾ in.).
National Gallery of Art, Washington, D.C., Chester Dale Collection, 1963.10.95.